T0106195

Color Me Trendy

Poetry by: **Rada Radmanovic**

Illustrated by: **Ljubica Radmanovic**

Creative Director: **Jasmina Radmanovic**

author**HOUSE**®

AuthorHouse™
1663 Liberty Drive
Bloomington, IN 47403
www.authorhouse.com
Phone: 1-800-839-8640

© 2010 Rada Radmanovic, Illustrated by: Ljubica Radmanovic, Creative Director: Jasmina Radmanovic. All rights reserved.

No part of this book may be reproduced, stored in a retrieval system, or transmitted
by any means without the written permission of the author.

First published by AuthorHouse 8/24/2010

ISBN: 978-1-4520-5795-8 (sc)

Printed in the United States of America

This book is printed on acid-free paper.

Because of the dynamic nature of the Internet, any Web addresses or links contained in this book may have changed
since publication and may no longer be valid. The views expressed in this work are solely those of the author and do not
necessarily reflect the views of the publisher, and the publisher hereby disclaims any responsibility for them.

Color Me Trendy is for those who:

Enjoy coloring and love color

Need to kill some time

Are bored at work, are bored at home, are bored period

Need a creative outlet

Love fashion

Love art

Color the pictures as they are or add your own twist with patterns and backgrounds. There are several fully colored examples on the back cover of the book that may give you some ideas or inspiration. Frame them, tack them up in your cubical, stick them on the fridge. Have fun and

Color Me Trendy!

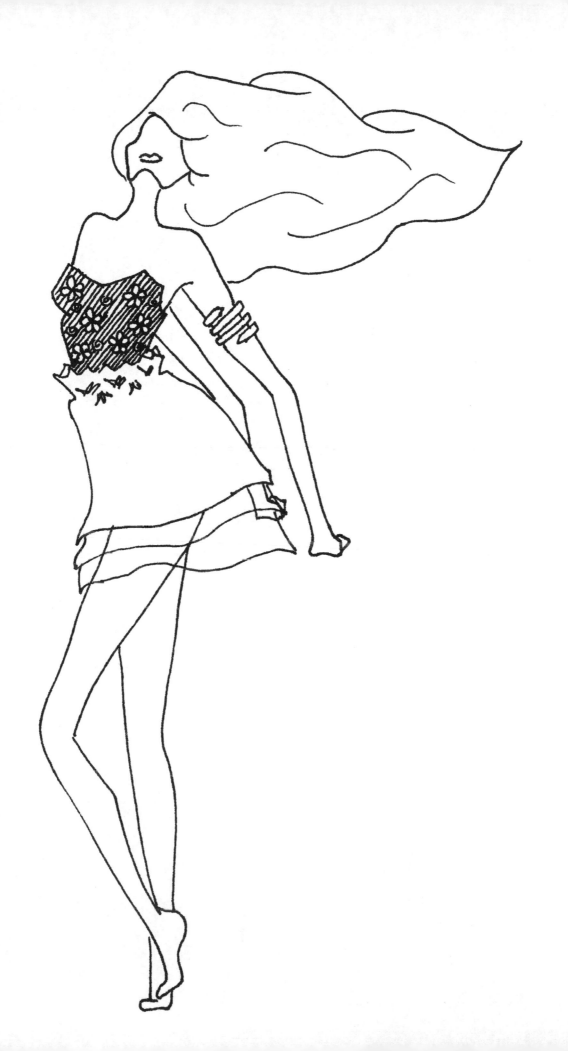

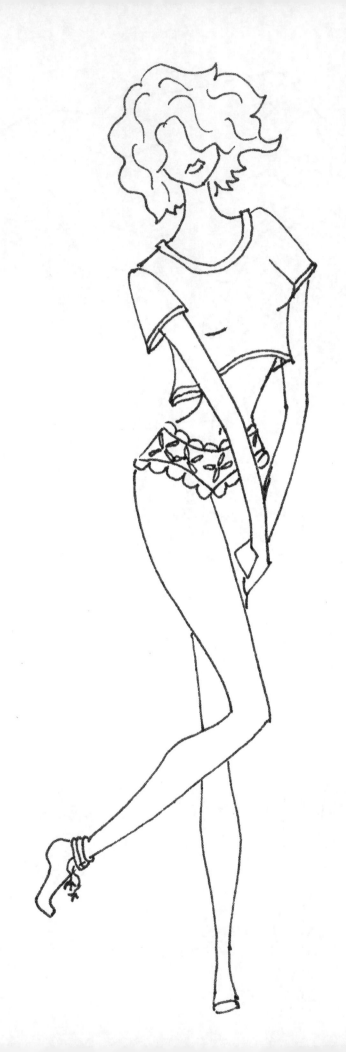

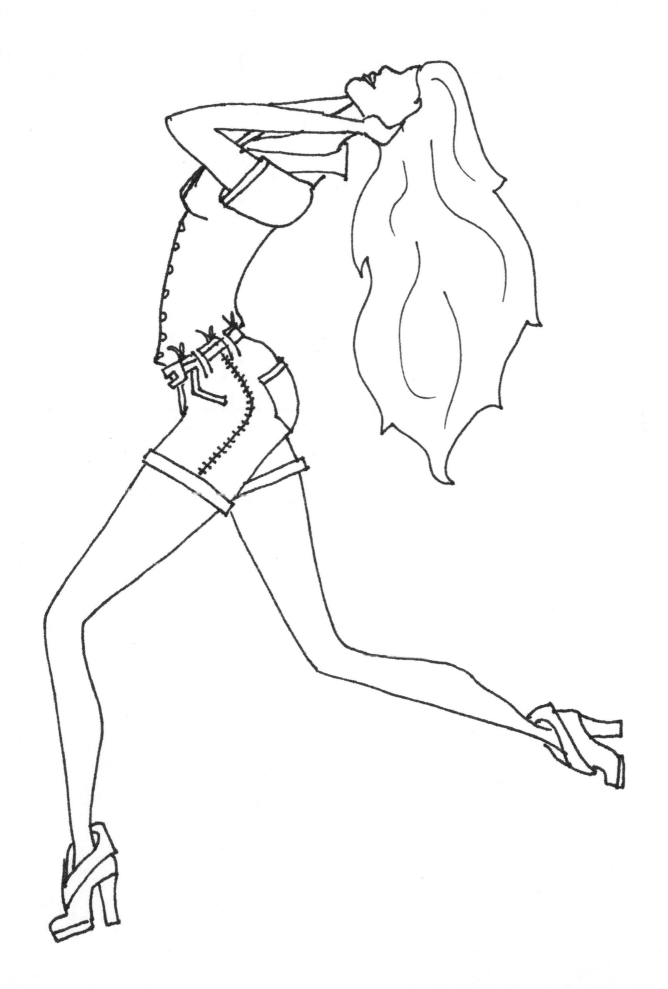

Tick tock, tick tock
Half an hour to go.
The girls have called,
Plans are set,
And I am ready to roll...

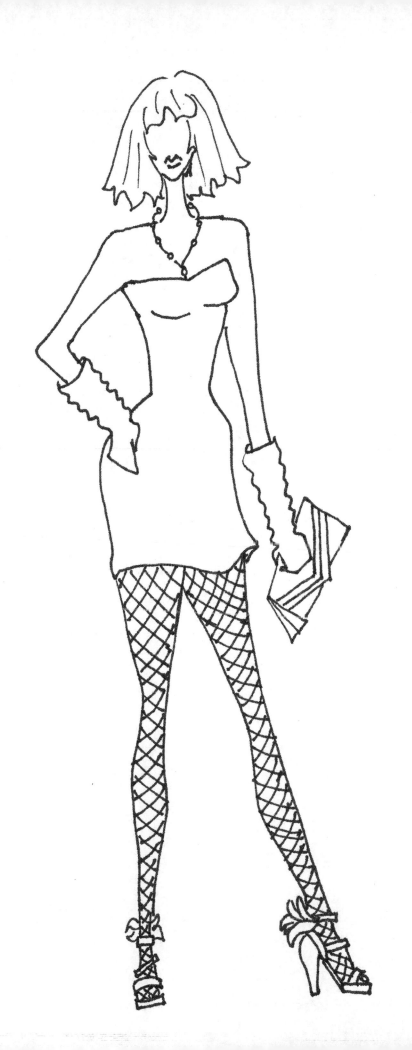

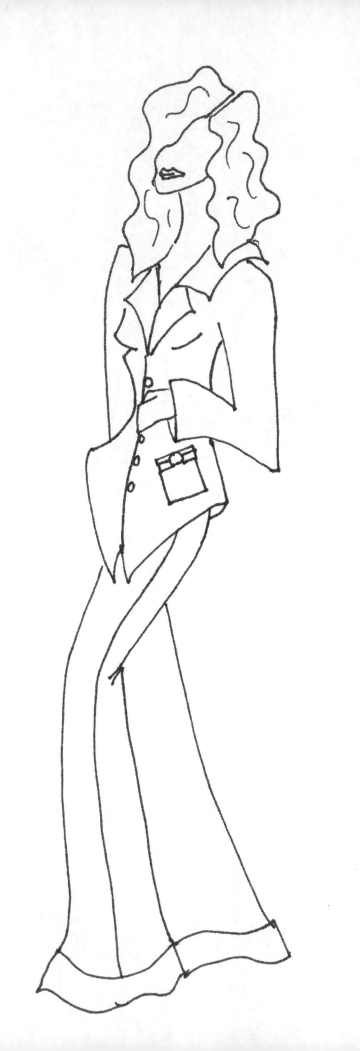

Decisions, decisions…
What to wear???
Too formal, not necessary,
Pile of clothes,
I don't know.
Maybe a good glass of wine
Will help set the mood…

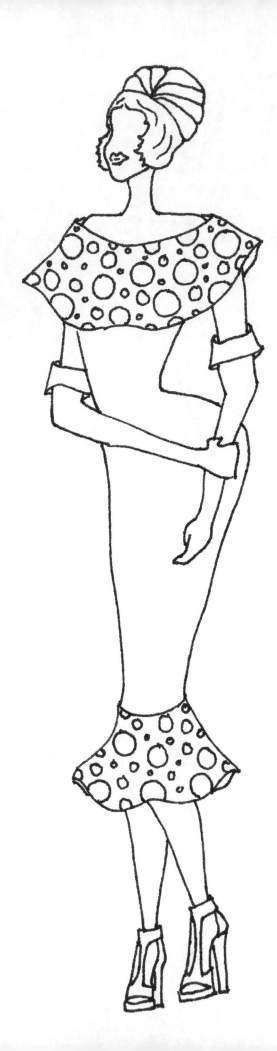

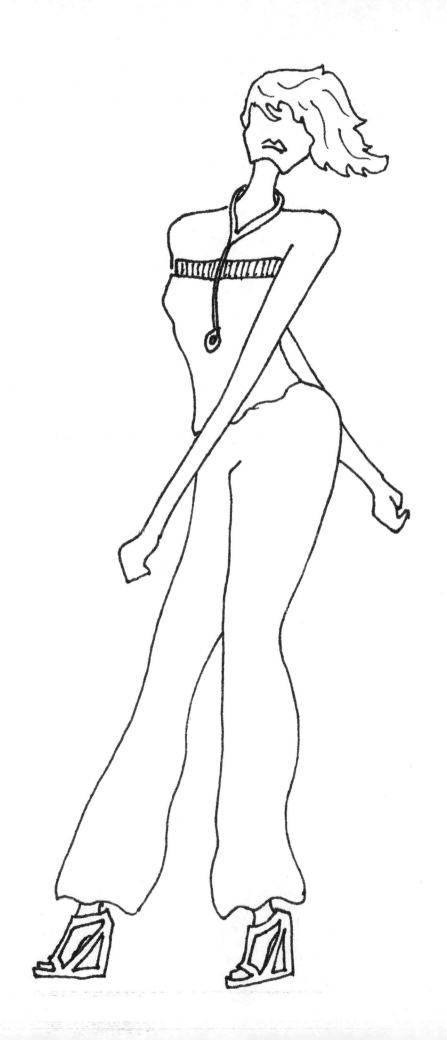

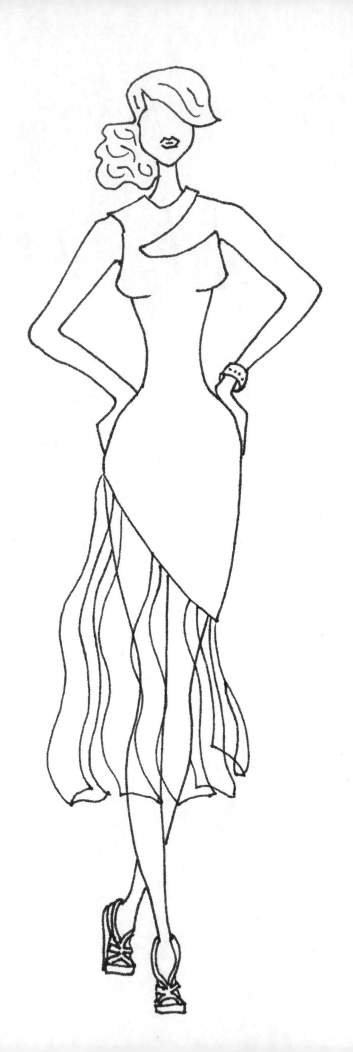

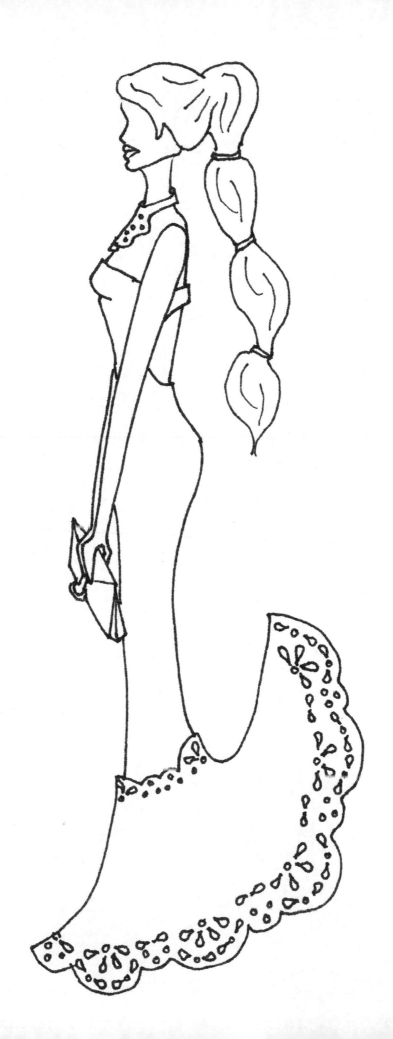

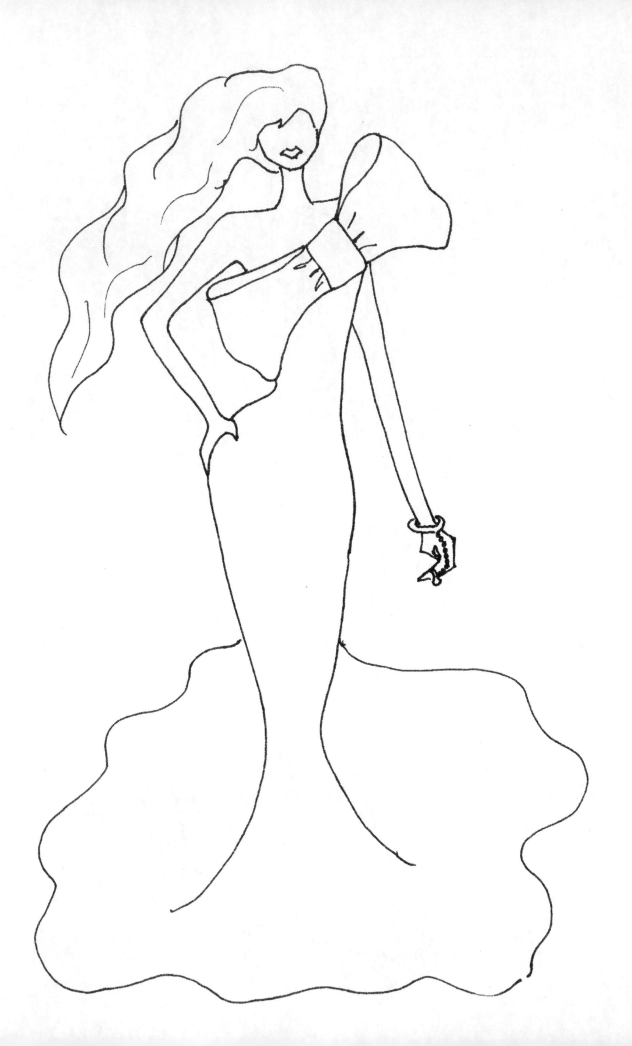

Experience life for all it's worth.
Take it,
Feed off it,
Do not allow it to slip away.
It's okay to put yourself first!

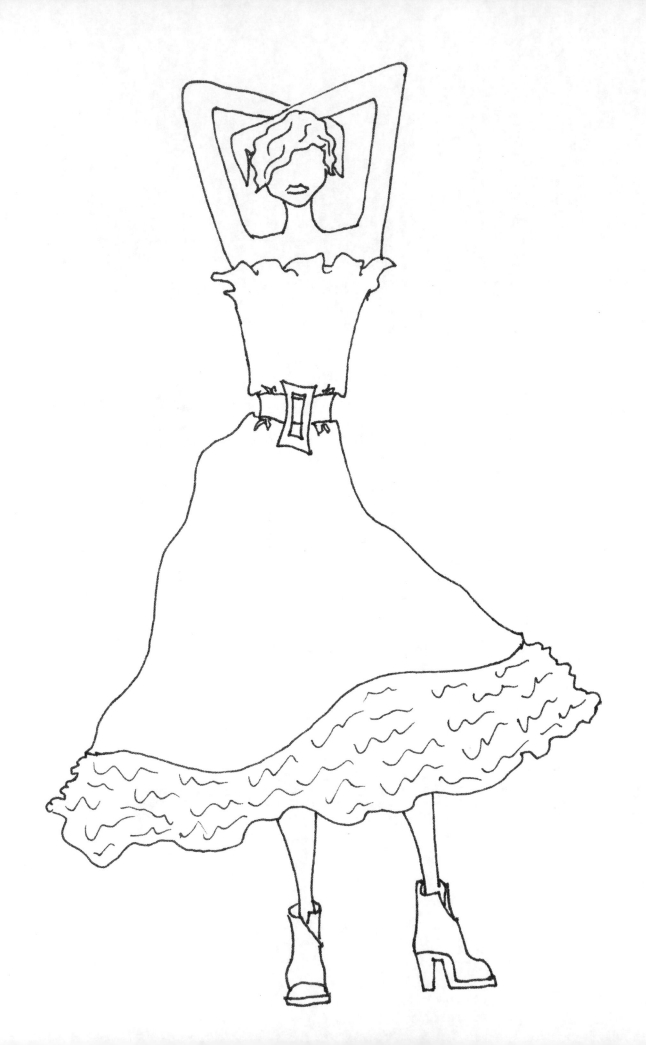

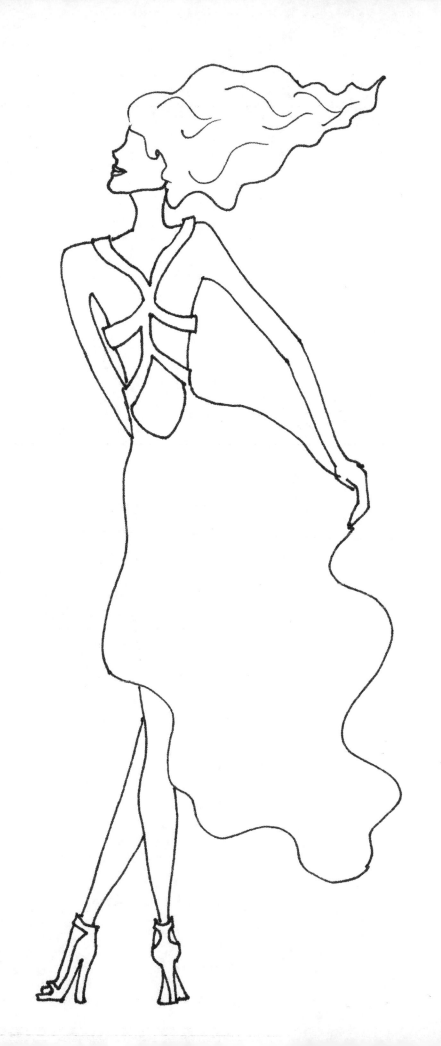

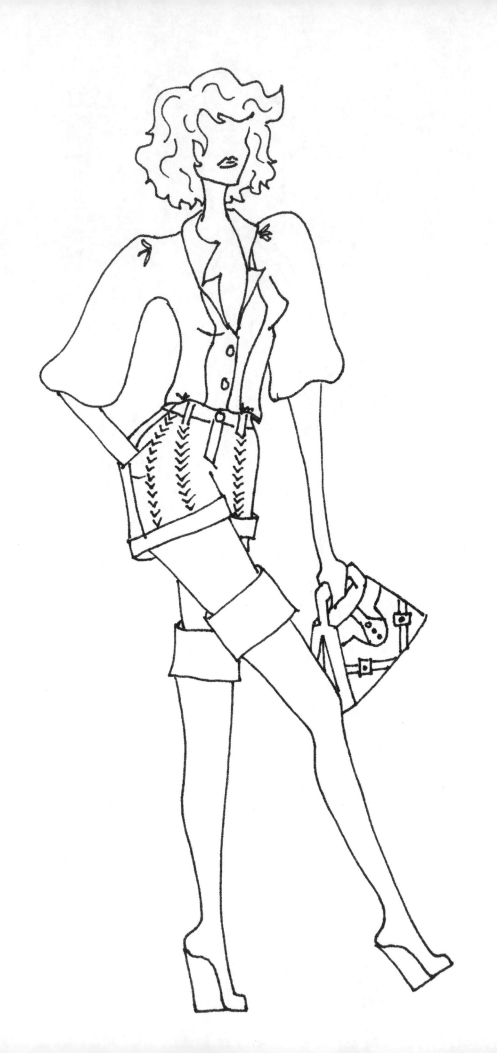

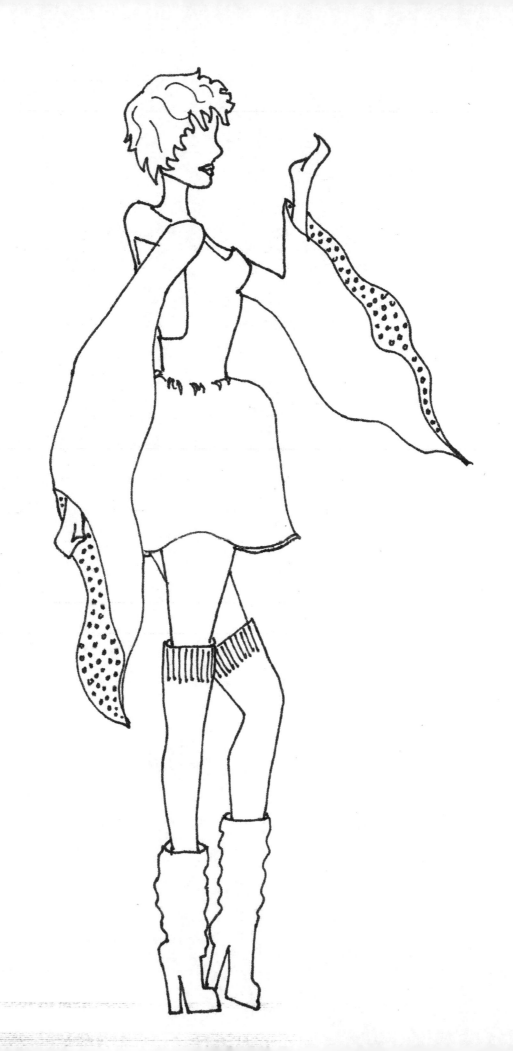

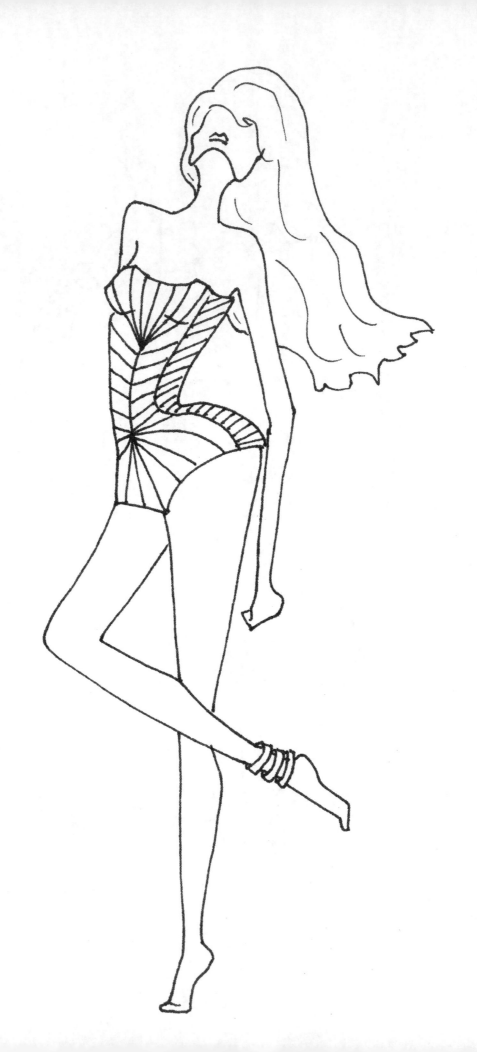

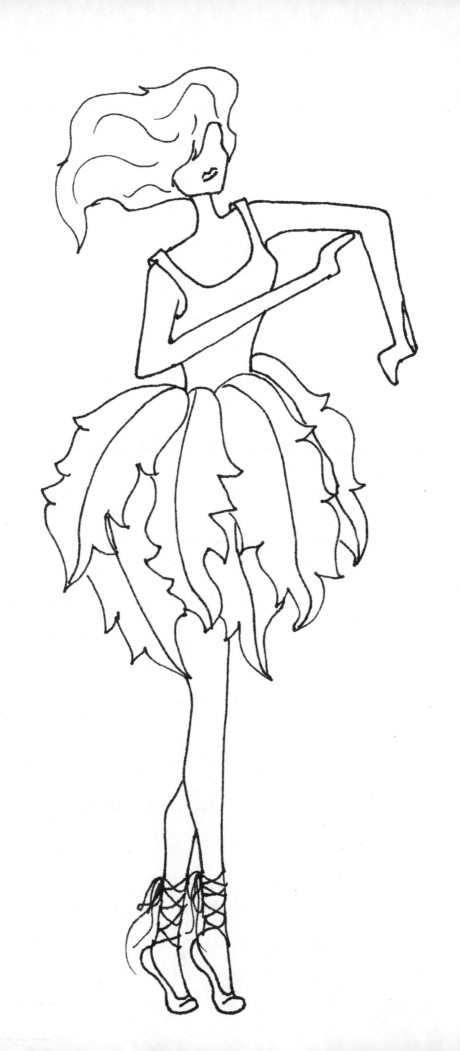

The sweetest time
Is coffee time.
Wake up with the morning sun
Shining through my window,
Aroma of fresh ground coffee
Brewing ready for me.
My favorite cup,
Hot steaming.
My favorite chair,
Comfy cozy.
Why can't I be here forever?

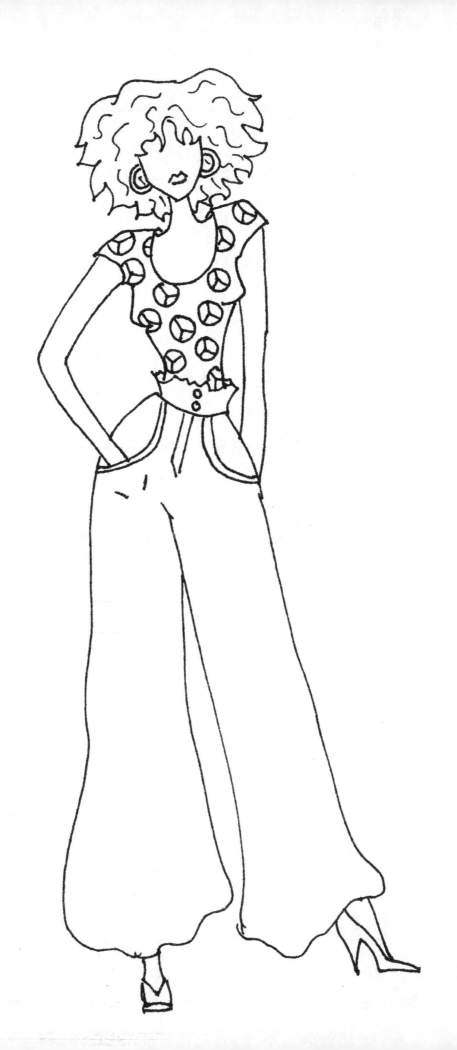

There's a feeling of empowerment

When you have that perfect outfit.

Silhouette of your body under the clothes.

The fit accentuates your best features,

The color to compliment

Your skin, hair, eyes,

Perhaps a belt to hug your waist,

A scarf

To drape, twist, tie.

Don't neglect the legs and feet.

Heels, flats, leather boots...

Whatever makes your stride

Strong and sexy.

You are in control and everyone knows it!

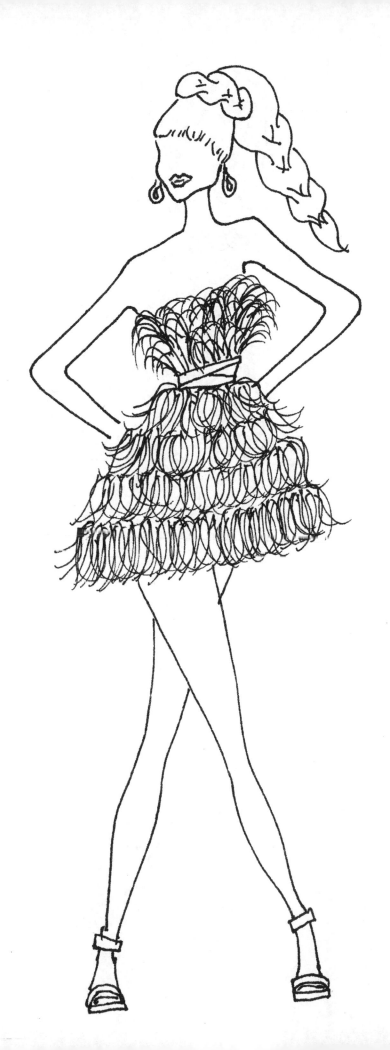

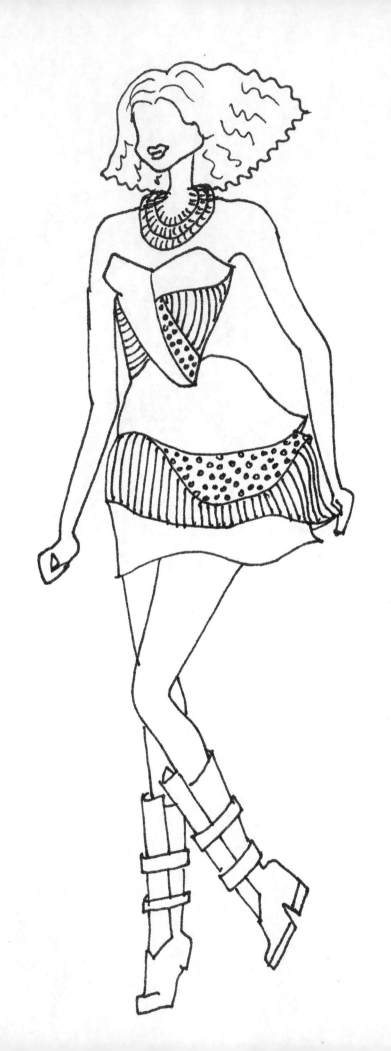

Boots to clothes,

It's like food to the body.

You just need it!

Ankle boots, thigh highs,

Leather, suede.

What is a boot if not sexy?

It gives an edge to the outfit,

An attitude to the wearer,

A picture of power to the intended audience.

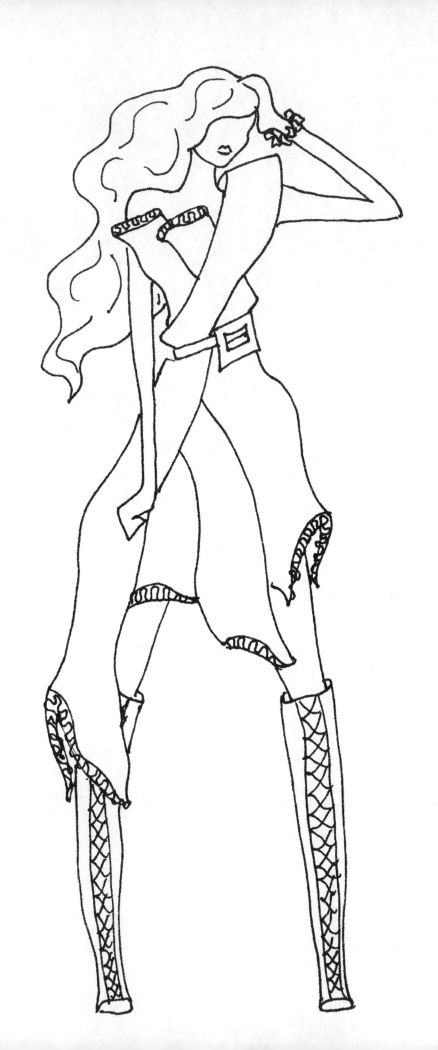

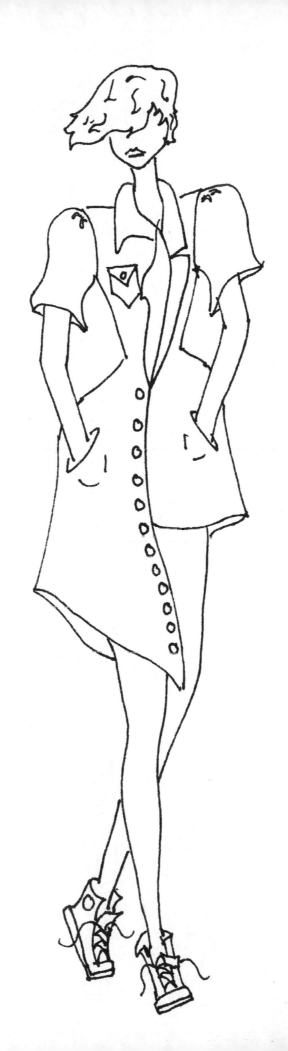

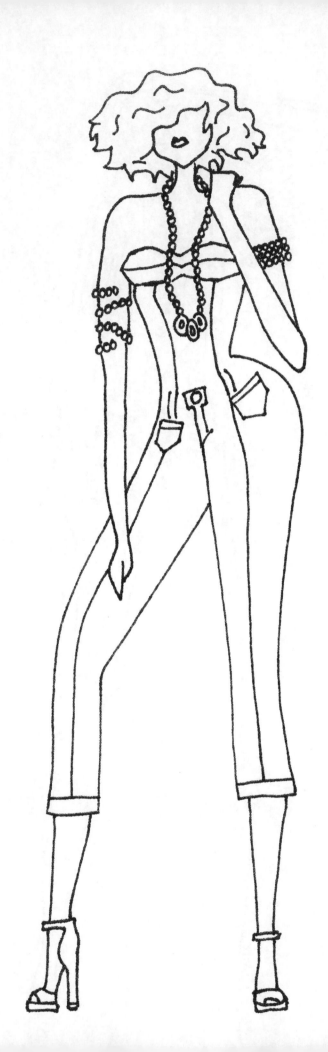

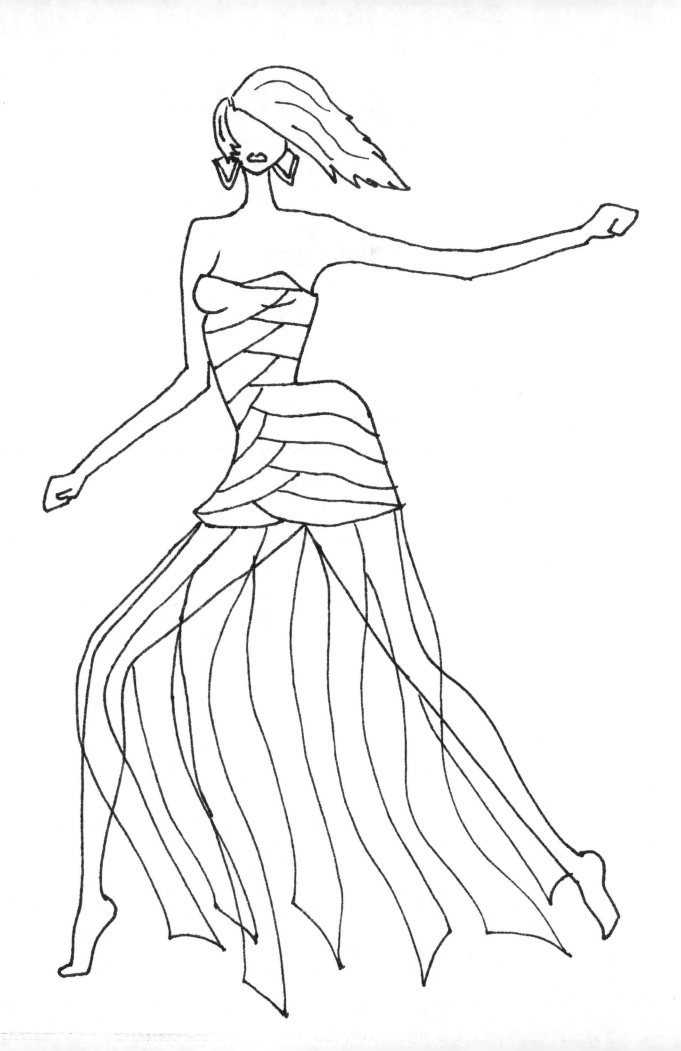

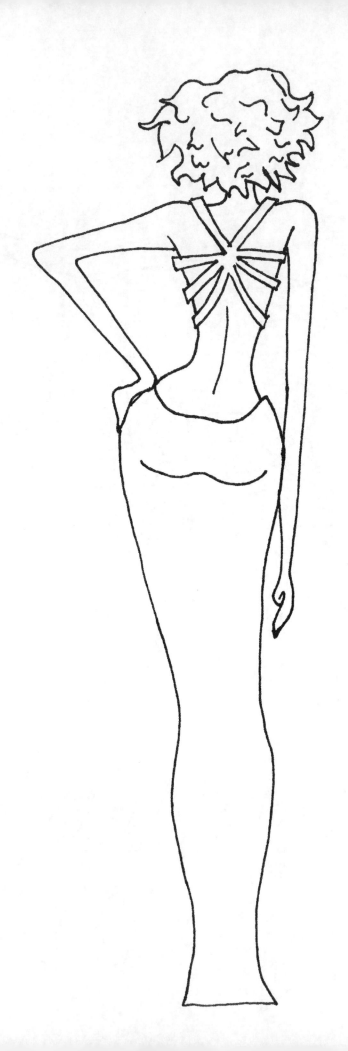

Cool summer breeze,

Dress wrapping around my legs.

Soft, wet sand under foot

Strolling down the beach.

Heels in my hands dangling from their straps.

The sun is setting,

The colors are surreal.

The waves are crashing

The sound both deafening and calming

All at once...

I love it here.

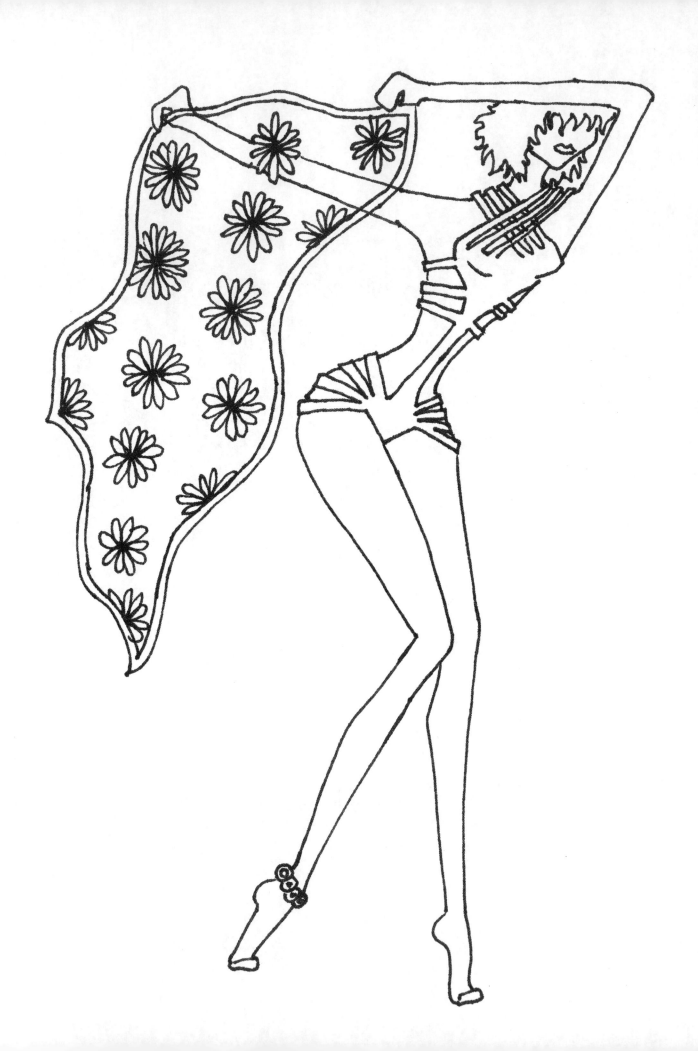

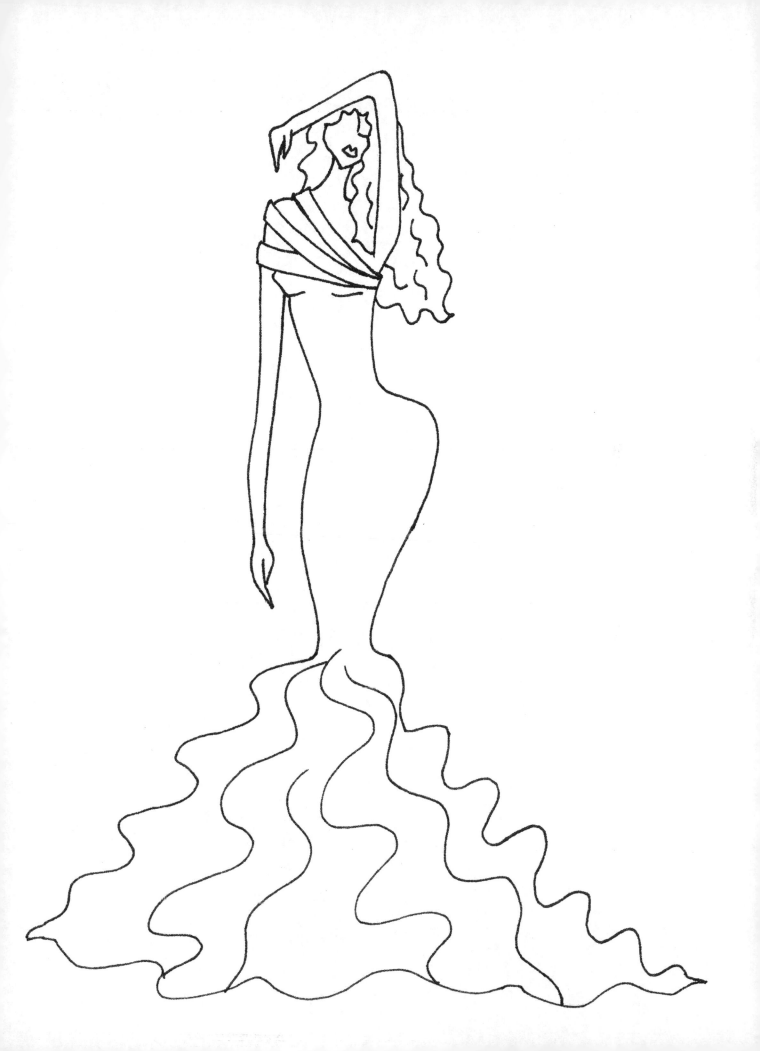

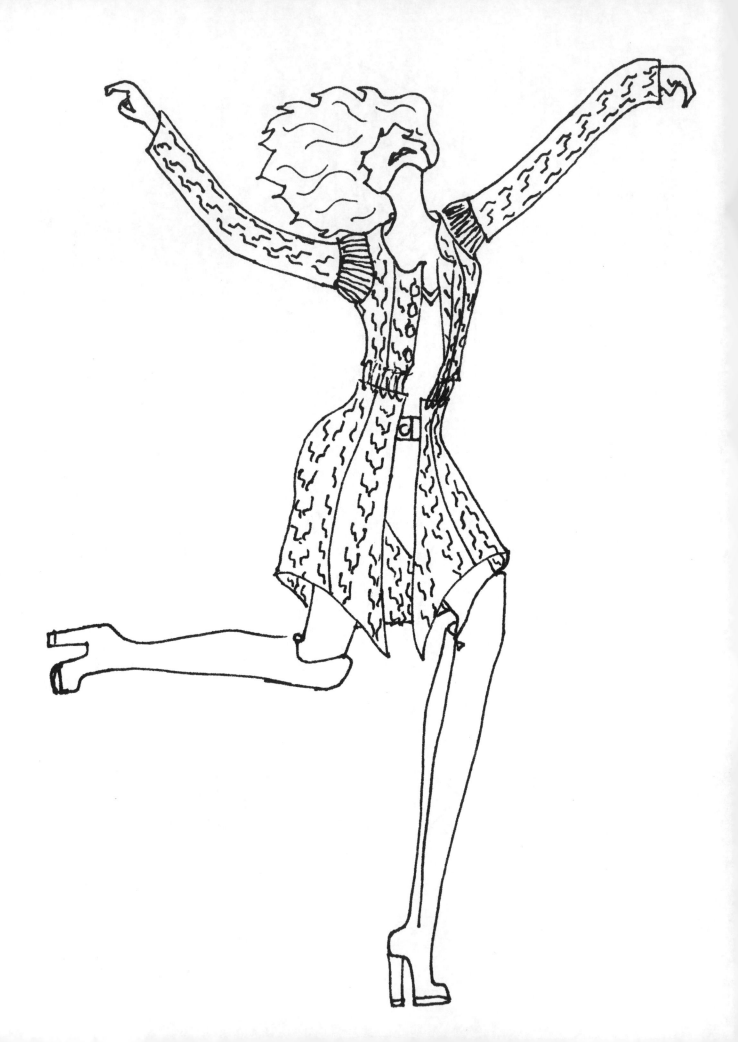

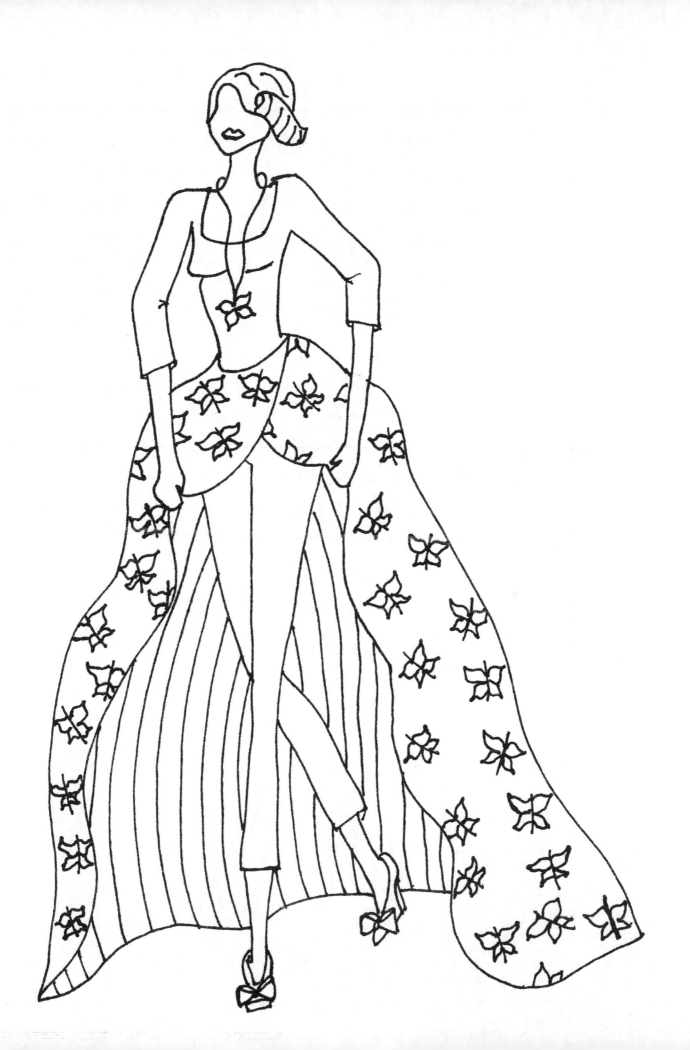

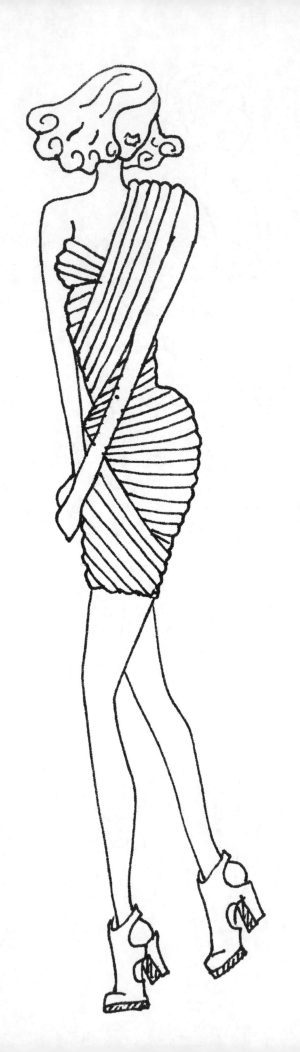

I hope that I'm not
"out of line"
When I say that daydreaming
Is a natural occurrence at work.
Come on,
We all do it.
Who doesn't think of
White sandy beaches,
Tall cold drink in hand,
Sand between your toes...
Well that's my daydream,
Think of your own.

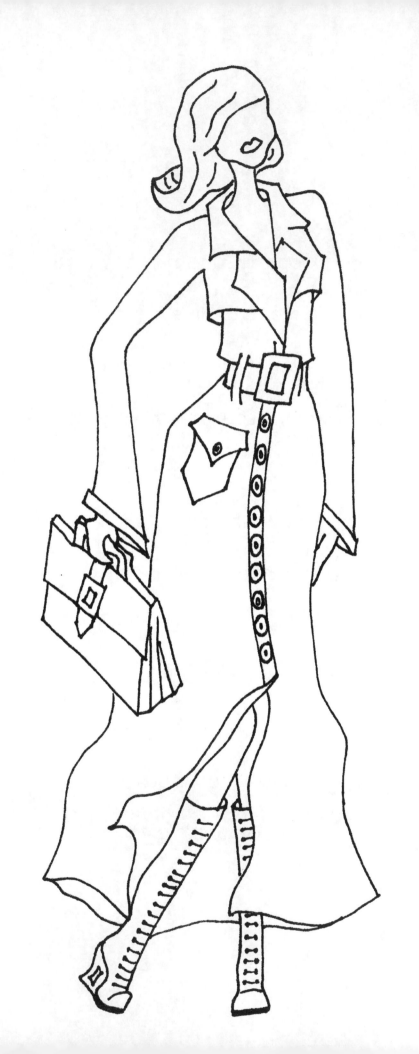

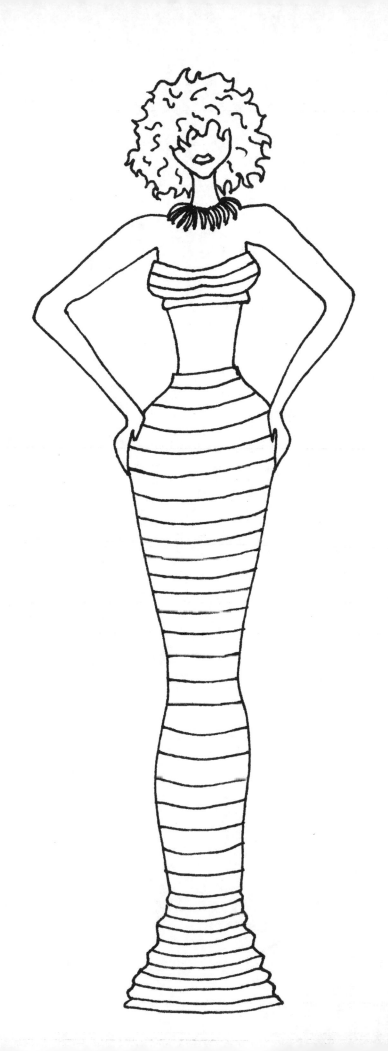

Clothes are a living portrait of self expression.

They show a mood, a feeling.

They help describe a lifestyle, a mindset.

They are the simplest way of saying

This is me.

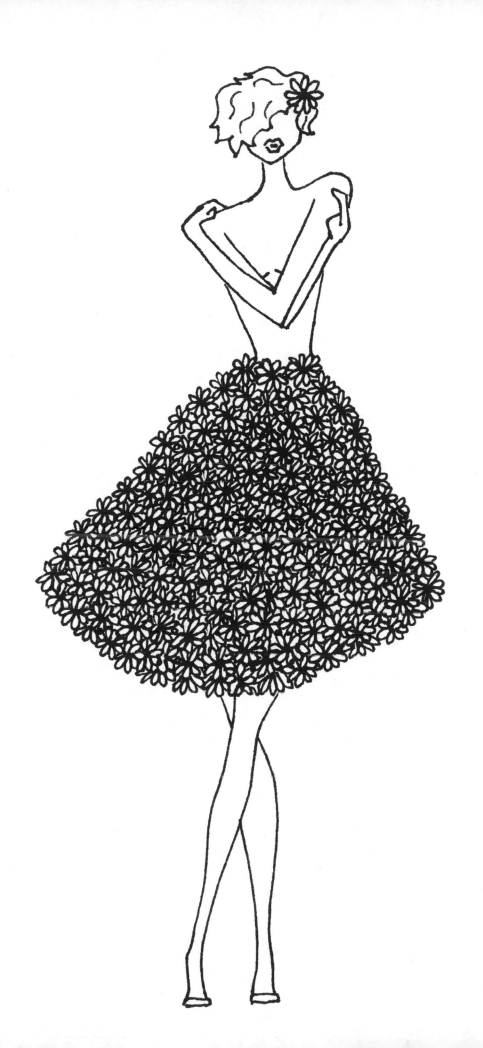

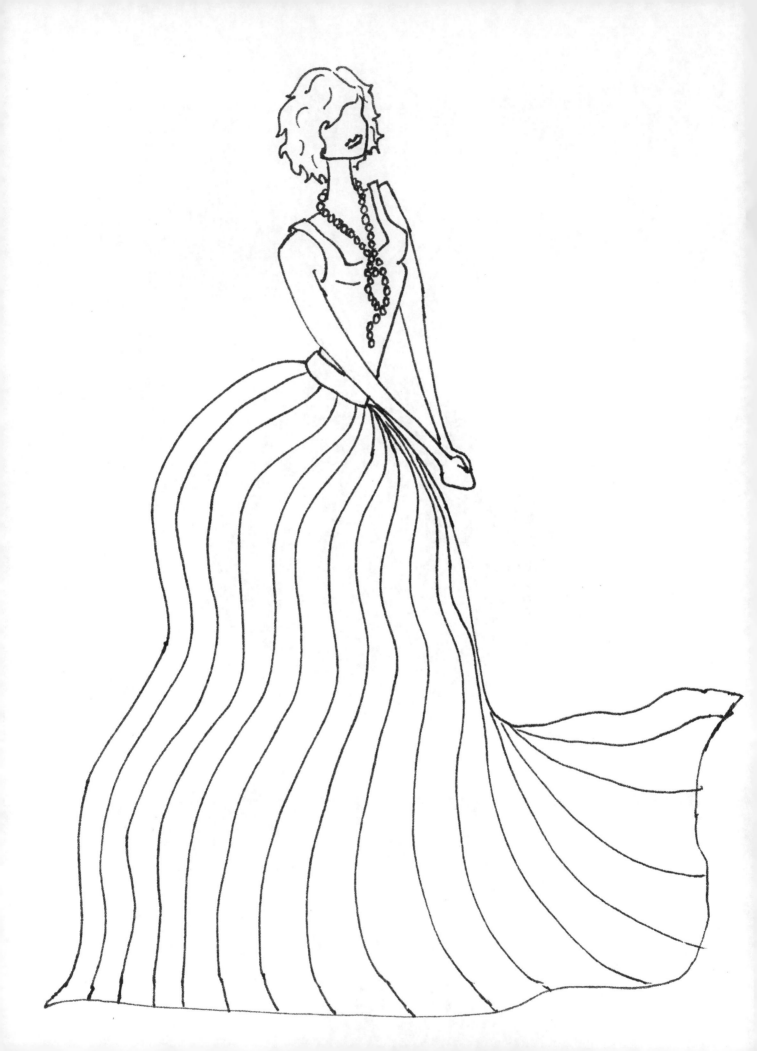

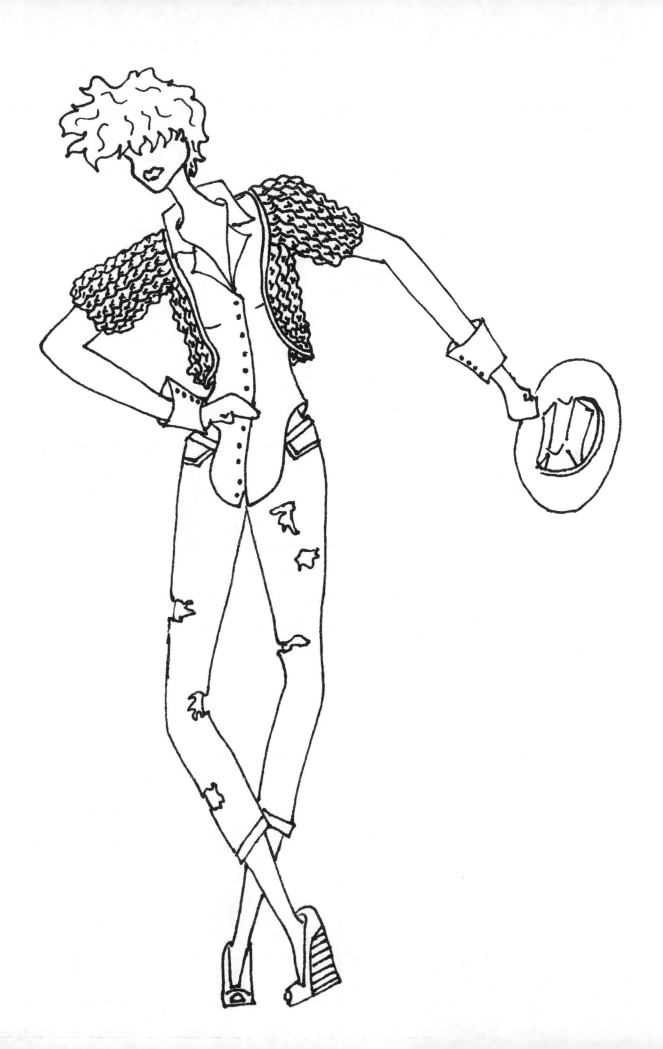

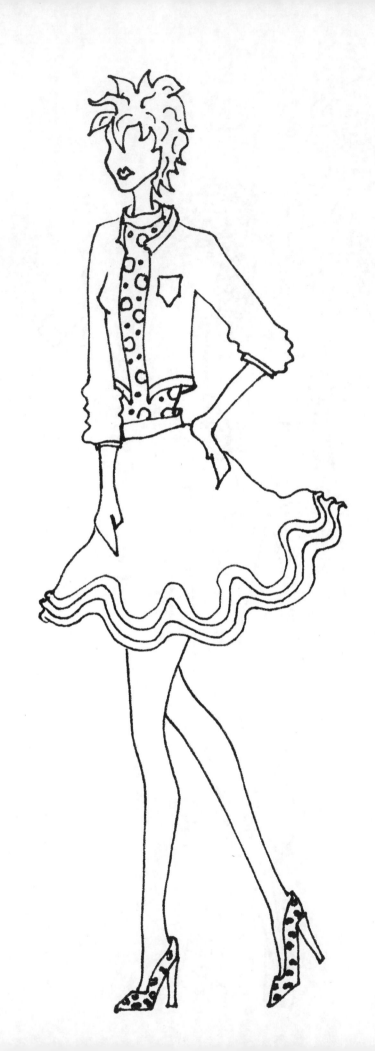

Wine blood red,
Sweet between my lips,
Smooth cascading down,
Fill that glass again,
Just a few more sips.

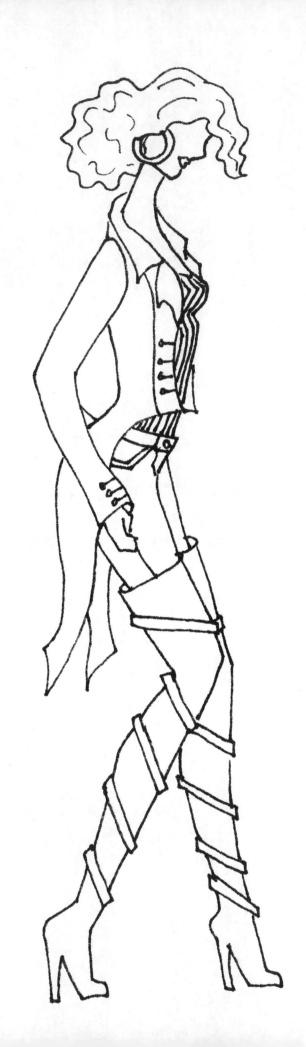

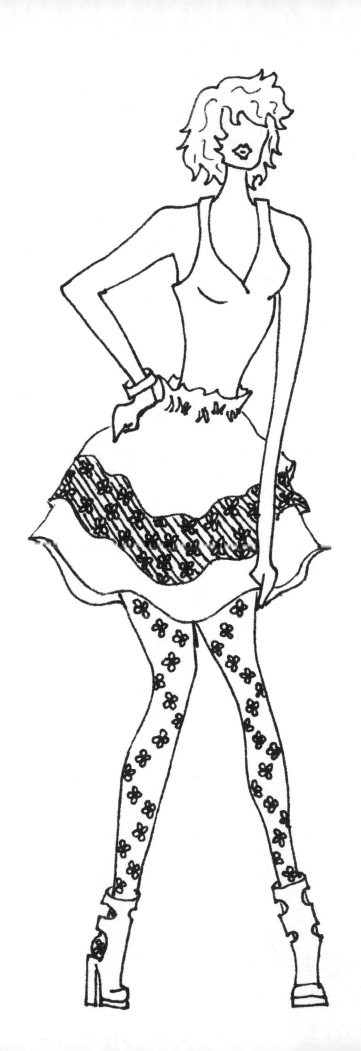

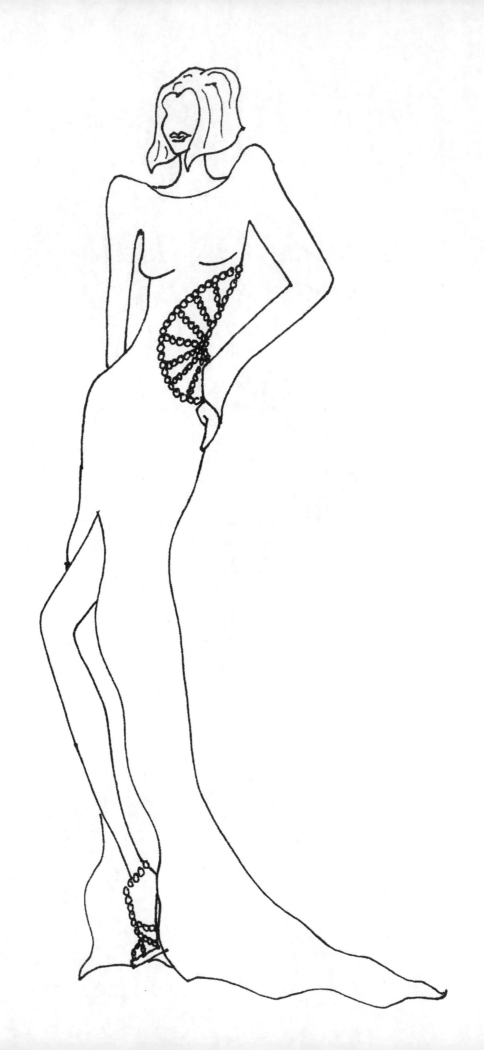